Happy Talk

Happy Talk

Bright Thoughts on Friendship, Love, Joy, Happiness and Beauty

Illustrated by Marty Links

Hallmark Crown Editions

A giggle a day

Keeps the glums away.

There's something wonderful
to see in every day.

A soft little touch

Can mean so much.

In big and small ways,

there are always

new joys to be discovered.

You need a friend

to make a teeter totter

(Like it oughter) !

So many good things

can get their start

From dreams and wishes

in the heart.

When we make

the world nice for others,

we make it nicer for ourselves.

When you've got someone terrific

on your mind,

Other thoughts are hard to find.

If you feel like shouting

"hip-hip hooray!"

Just because it's a beautiful day--

Do it!

Sending a note

that you wrote is fun...

But getting a letter

is really lots better!

Any day is lovely

when we're doing what we love.

Friends multiply our joys
and divide our cares.

Every time the sun shines,

a flower says, "Hello!"

There's no such thing

as too many friends.

Just thinking of love

can fill a day with joy!

Happiness can be a little nap

When your zip has lost its zap.

Once in a while, for a smile,

Try a yummy in your tummy!

Having-fun-together times

Are bright-and-sunny-weather times!

a "friend-to-friend" call...

Is always a ball!

We never know

when we may meet

that "special" person.

It's the thought that counts a lot.

(Whether we say it right or not.)

It's the nicest feeling under the sun

When someone says,

"Well done. Well done!"

Always save a little corner

of every day--

just for fun!

There's a little heaven

in us all...

And there's a little devil

in all of us, too!

Nature has the nicest way

Of adding beauty to every day!

Harps go plinkety, plankety, plunkety

And loving hearts go bumpety - thumpety!

Happy thoughts

can make us smile

inside and out.

Little things mean a whole gob!

Together

is a wonderful place to be!

When you miss somebody,

it's like dropping

your ice-cream cone

and having your balloon

fly away both at the same time.

Don't hurry,

don't worry,

don't forget to smell the flowers.

When you like somebody,

It's good to show it!

(Otherwise, how will

They know it?)

Let a smile be your umbrella,

and a laugh your sunny day.

A hug a day

Keeps the blues away.

Whenever we sing--

Instant spring!

It's lovely to see

eye to eye

and nose to nose!

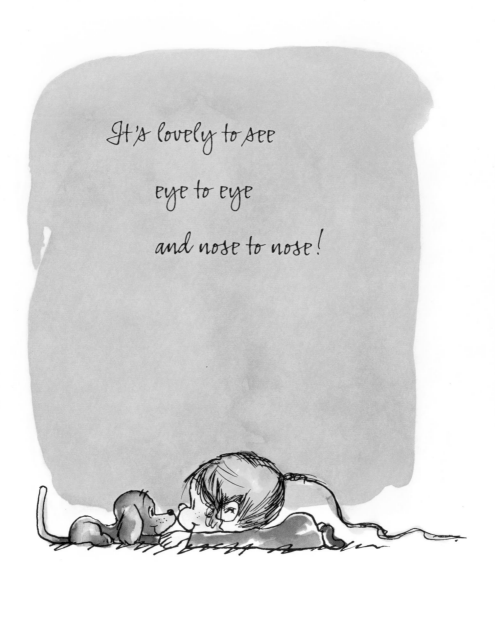

Everything is sweeter

when it's shared.

A little creating always makes
your brain feel good.

Look in the mirror every day

and tell yourself

that you're OKAY!

The world's chock-full
of the nicest surprises!

Set in Butch, an informal calligraphic style
created exclusively for Hallmark.
Printed on Hallmark Eggshell Book paper.
Edited by Tina Hacker.
Book design by Lavonia Harrison.